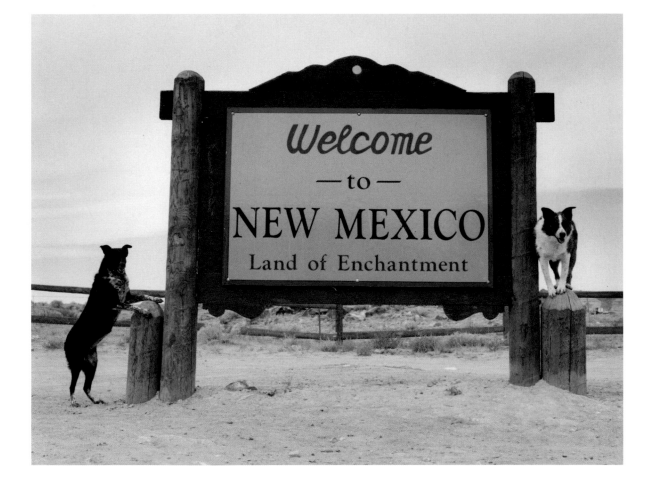

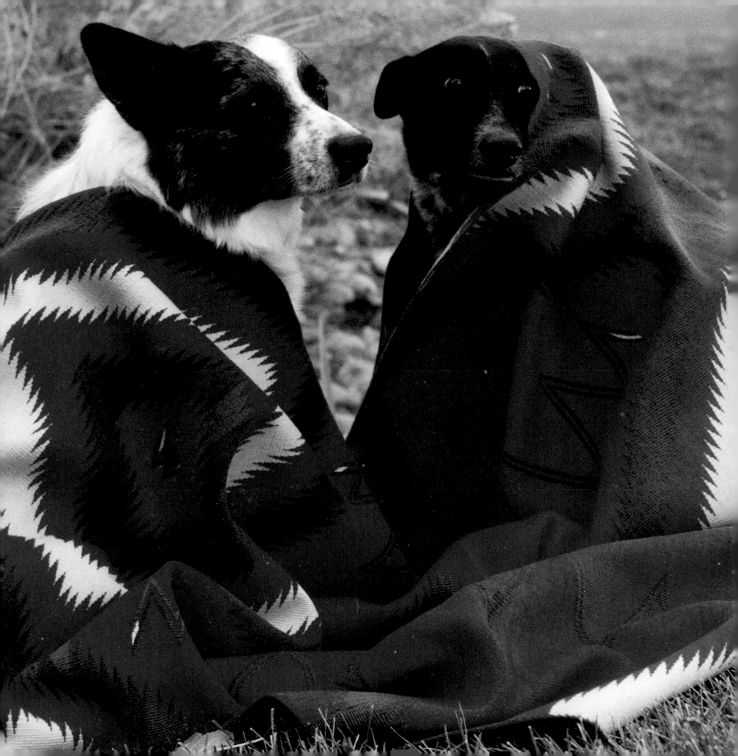

THE ADVENTURES OF
BRO & TRACY

BY JOYCE FAY

CollinsPublishersSanFrancisco
A Division of HarperCollins*Publishers*

Library of Congress Cataloging in Publication Data

Fay, Joyce
The Adventures of Bro & Tracy / Joyce Fay.
p. cm.
ISBN 0-00-255111-X : $16.95
1. Photography of dogs. I. Title II. Title: Adventures of Bro and Tracy.
TR729.D6F39 1993 92-41084-CIP

Printed in Italy by Mondadori A.M.E. Publishing LTD.

I wish to thank Andrew Nagen,
for kindly providing the Navajo blankets.
And thanks to the National Park Service for giving me
permission to photograph in Casa Bonita,
Chaco Culture National Historic Park

Page 1: Welcome to New Mexico Sign, Four Corners
Page 2: Navajo Blanket, Corrales, New Mexico

To my parents, Doris and Richard Fay,
and my partners, Ed, Bro & Tracy Camron.

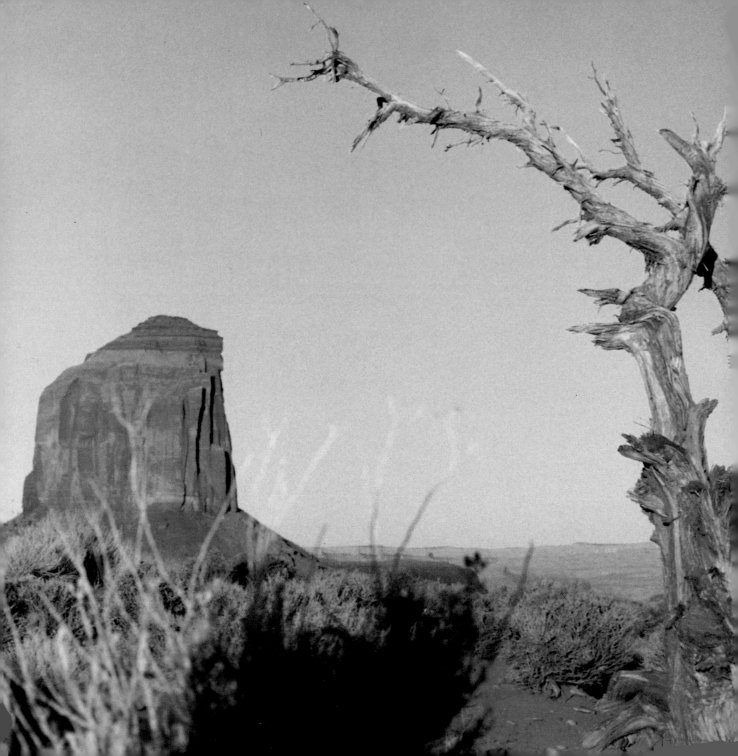

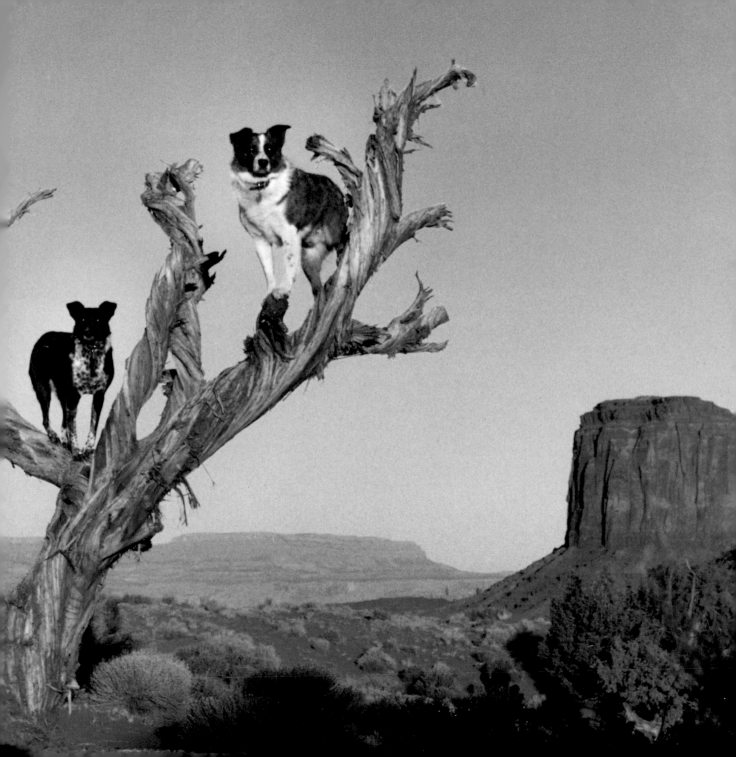

One windy March day, Bro and Tracy and I
were in Monument Valley. We didn't have
anything to do so I asked them to climb trees.
I snapped a few pictures of them in the trees. People
asked, "How did you get them in the tree?"

It was just a game. They're agile, have good balance.
I knew it was something they could do.

I am often asked about my training methods. What
we have done is not so much "train" dogs, as develop a
relationship with them. Climbing trees wasn't the goal.
It was the accidental result of the relationship, a relation-
ship that involves having fun, communicating, traveling
and enjoying dogs.

PREVIOUS PAGE: MONUMENT VALLEY, MORNING
RIGHT: ON THE ROAD TO MONUMENT VALLEY , UTAH

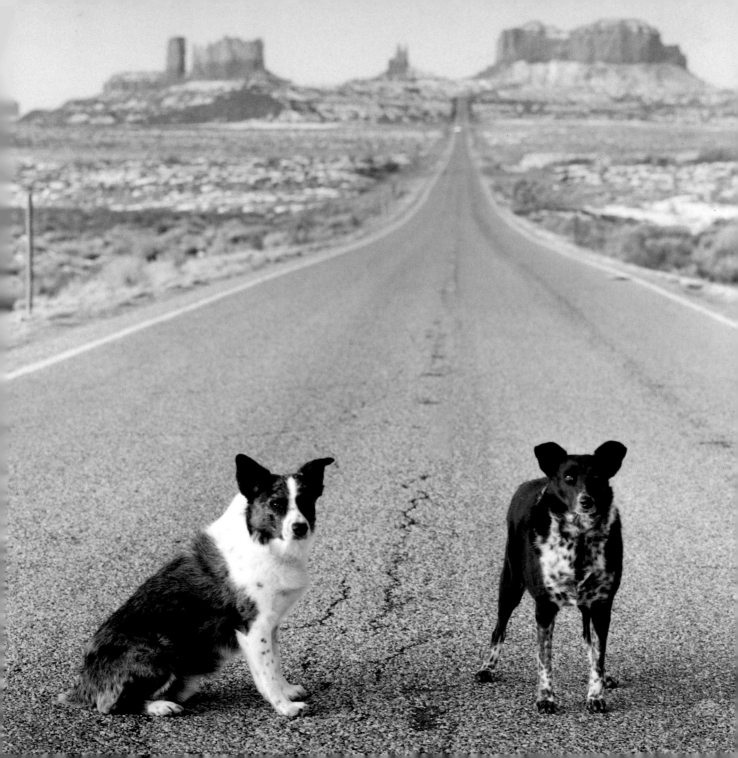

This is a love story and this is how the story began: In June, 1985, my husband Ed came home from work and said a man he knew had a puppy and it was the kind he always wanted. That was fine. But the puppy had a sister. I thought puppies were like parakeets. If you raise two together they won't listen to you. I hate to think if I had gotten my way at the time. We would have missed the pleasure of having both Tracy and her brother Bro. Since then they have been my two tails. When Ed and I are apart they are always with me. He doesn't say, "I love you," he says "I love you all."

We started out with a basic obedience class. Learning "sit" "come" "stay" and " heel" is an important step in being able to control and be responsible for your dog. Bro and Tracy have never been able to do the advanced class work. It would be fun if they could, but neither they nor I were sufficiently motivated.

Bro and Tracy would have liked to become herding dogs. But there weren't many opportunities available. We were not willing to acquire a herd just for them.

Little by little, as we became a family, their work came to be posing for photographs for me. When you try to take a picture of a dog he will usually run straight to you. Or run off. If you teach him "Stay" you will have a better chance to photograph him. Then the photographing becomes part of the training. That is, they're practicing their commands in a real-life situation.

Bro and Tracy enjoy working for me. They want to please. What is important for them is that they're doing something with me and pleasing me. The relationship grows. They get jealous when I photograph anybody else, human or animal.

Photographing Bro and Tracy became a way for me to represent my feelings about a place.

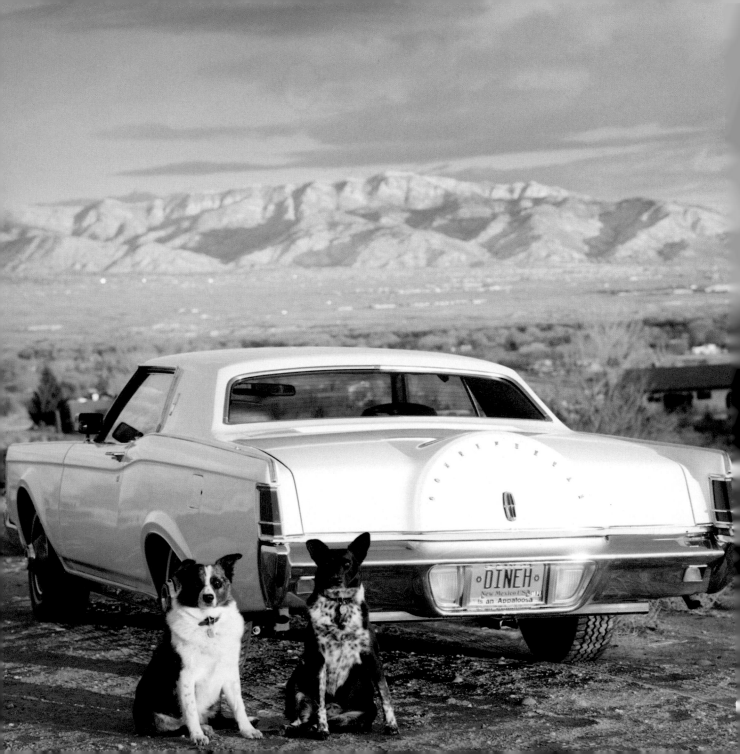

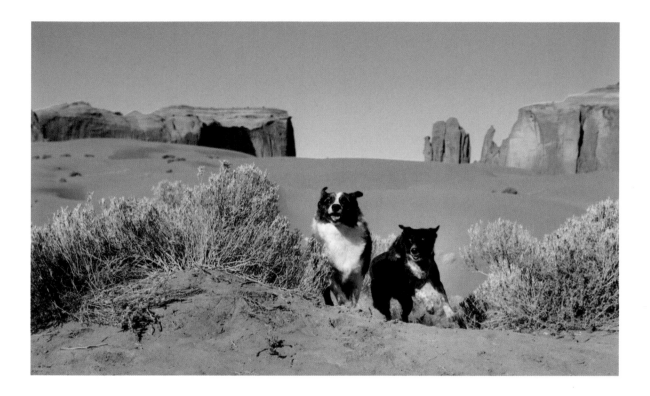

Ed and I each drive about 40,000 miles a year,
and Bro and Tracy usually come along.

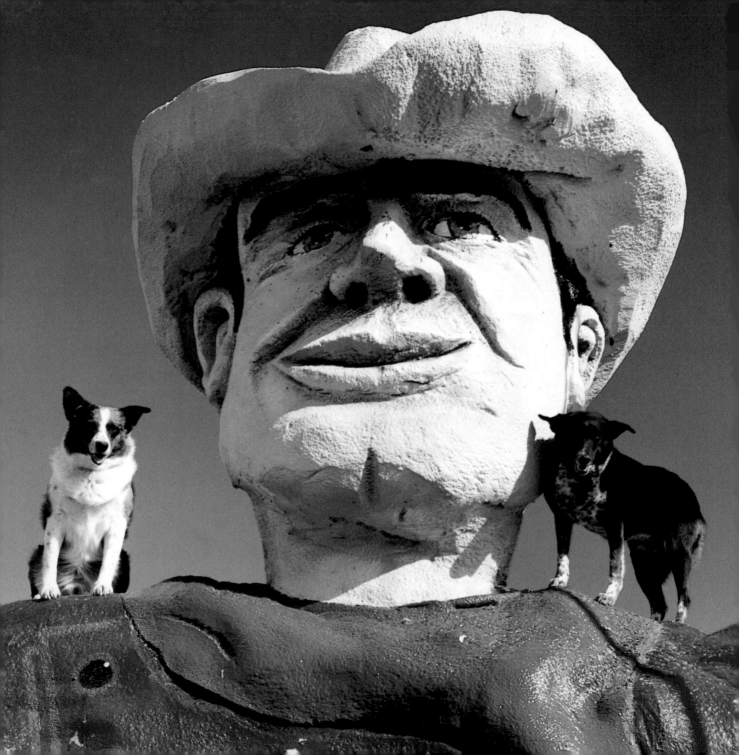

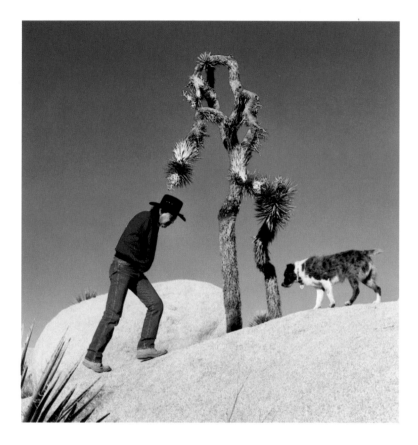

LEFT: BRO AND TRACY AND THE BIG COWBOY, ALBUQUERQUE, NEW MEXICO
ABOVE: BRO WITH ED NEAR JOSHUA TREE NATIONAL MONUMENT, CALIFORNIA

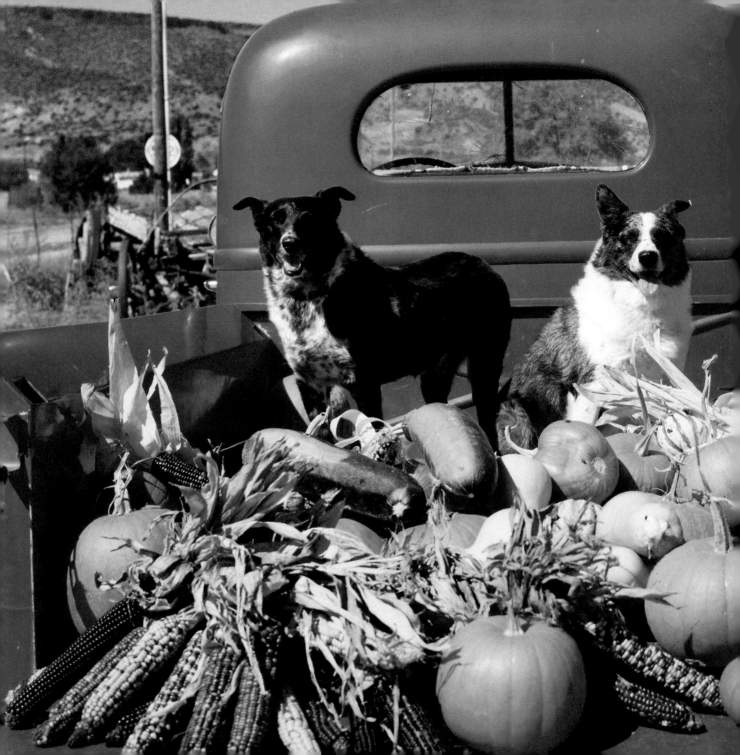

The red truck at Garcia's Corn Stalk Fruit Stand is famous. It's just always been there. Even though the dogs look posed here, I usually don't really "pose" Bro and Tracy. I start by telling them a general area I want them in and let them take their own poses. It was suggested that I could sometimes place one in front of the other instead of so frequently side by side. That was when I realized that this is what they choose. When one is in front, the other is jealous.

I have not yet been able to say to them, "act natural," and have them respond appropriately. But I've never met a person who could do that, either.

TRUCK AT GARCIA'S CORN STALK FRUIT STAND,
VELARDE, NEW MEXICO

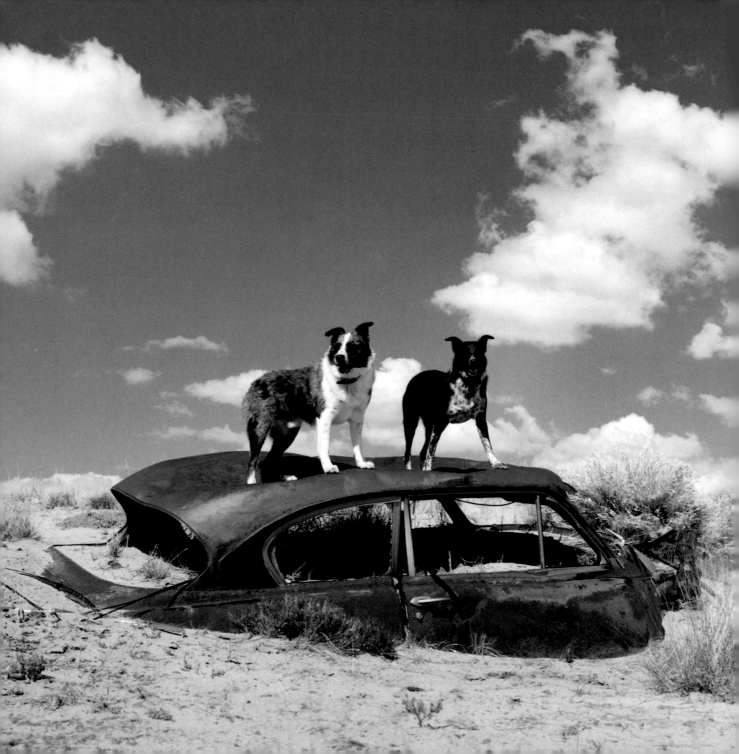

I read books and I talk to people who know about dogs. But I realize that my earliest instructors in dog training were dogs who belonged to friends of mine. They were the first to teach me what a dog is capable of doing. They were not trick dogs in a circus, but family dogs able to communicate with their families and fit into the everyday life of their people.

Now the lessons continue with Bro and Tracy. They taught me not to limit their intelligence by assuming their limitations.

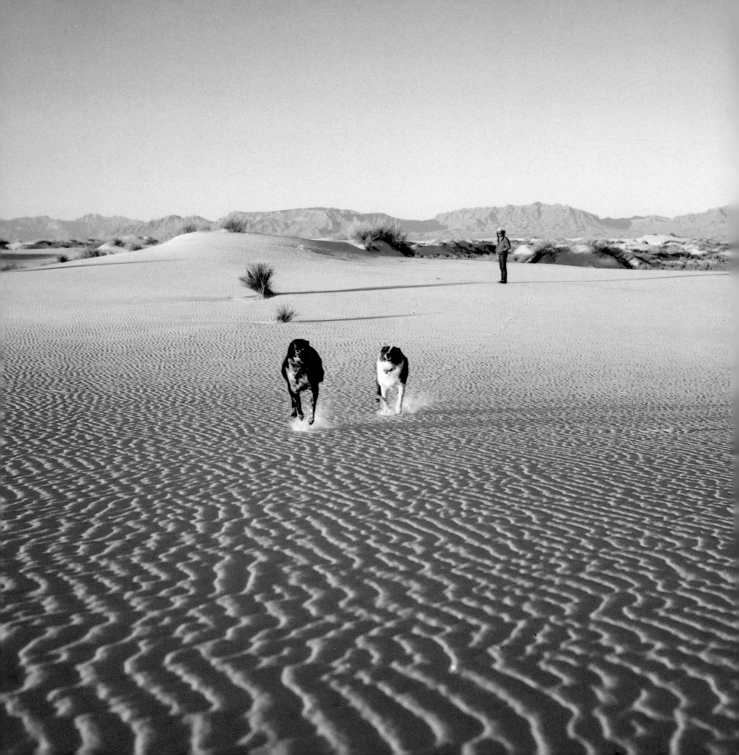

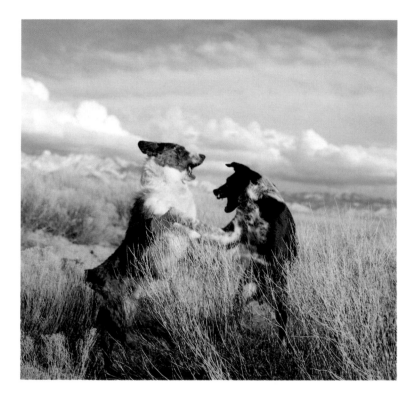

Bro and Tracy are not extraordinary dogs and I'm not
a trainer. These things with Bro and Tracy didn't
take hours of work. They took hours of play.

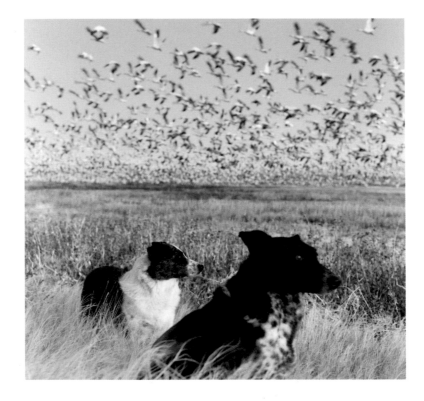

ABOVE: BOSQUE DEL APACHE NATIONAL WILDLIFE REFUGE
NEAR SAN ANTONIO, NEW MEXICO
RIGHT: NEAR MOAB, UTAH

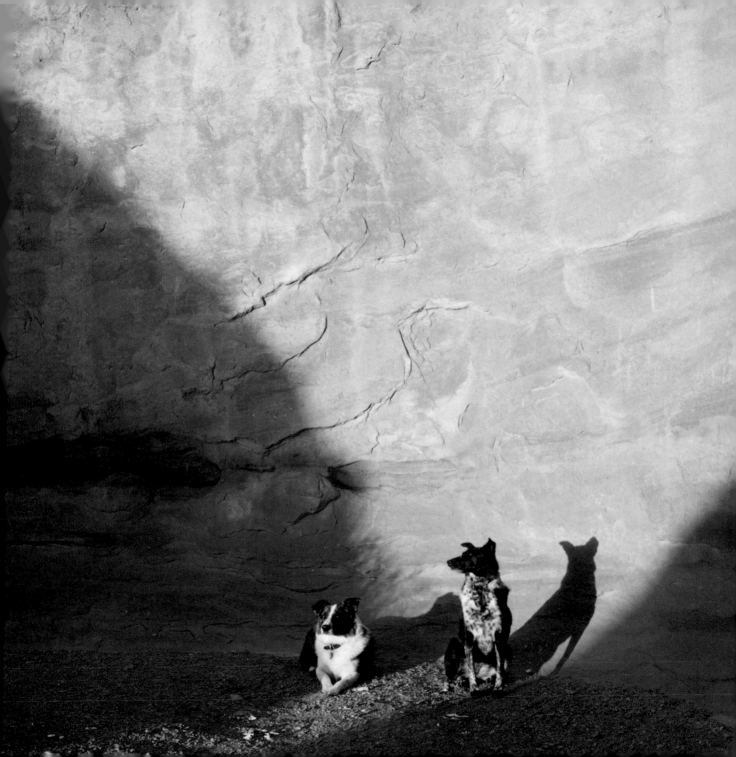

T o be able to photograph your dog you need to teach him one command...STAY. If you teach him "stay," at least you can keep him in place for a while, giving you the opportunity to compose your shot and focus.

Courtyard, Santa Fe, New Mexico

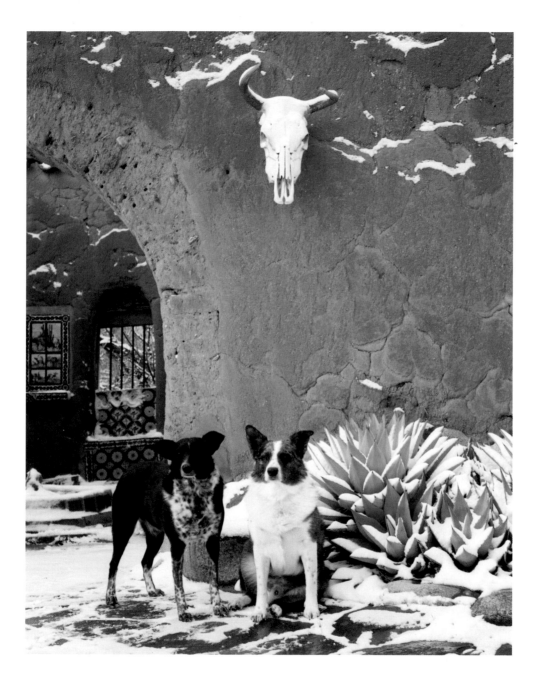

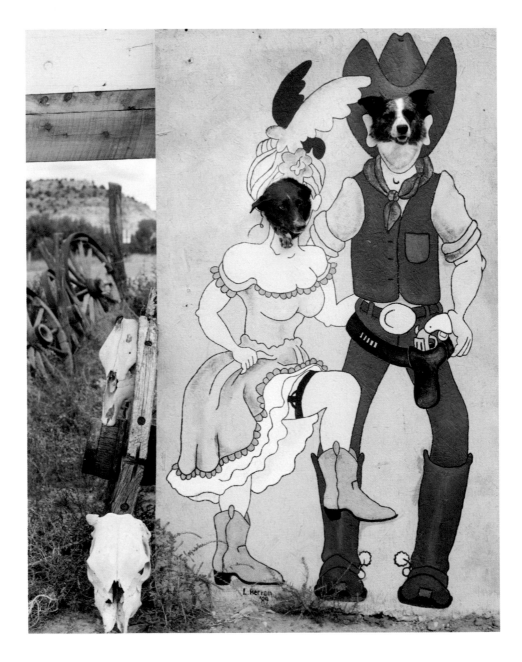

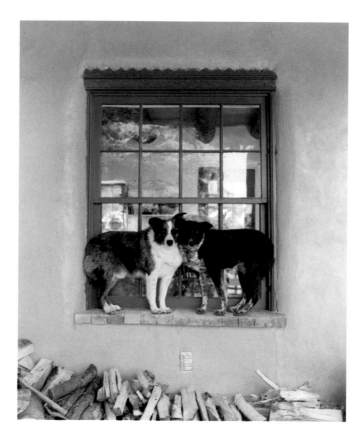

LEFT: CUT-OUTS IN FRONT OF BURR TRAIL CAFE, BOULDER, UTAH
ABOVE: WINDOW AT ADOBE AND PINES, TAOS, NEW MEXICO

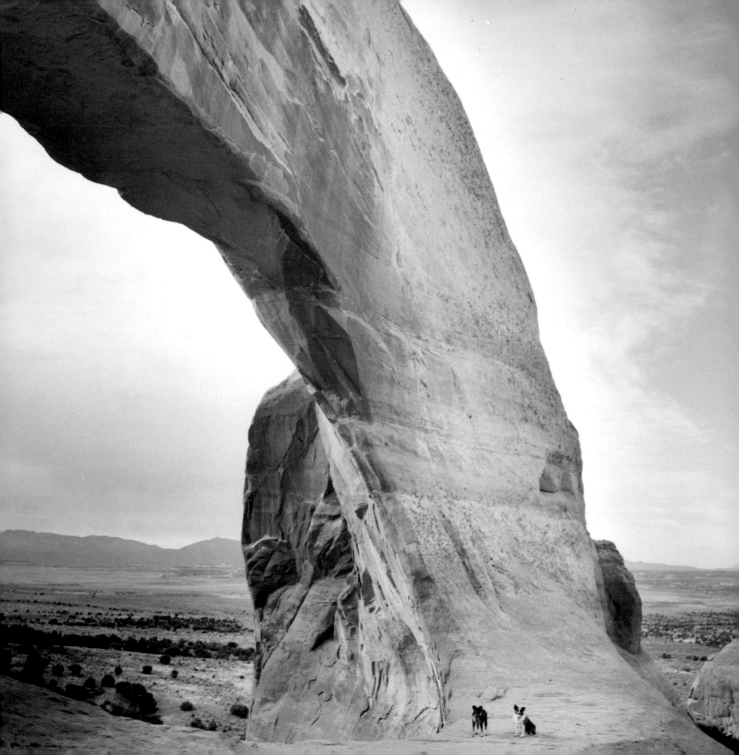

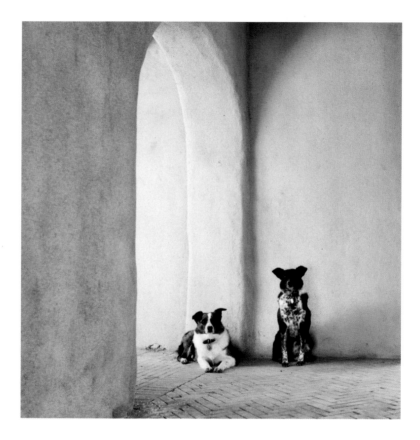

Bro and Tracy are still working on
taking commands at a distance.

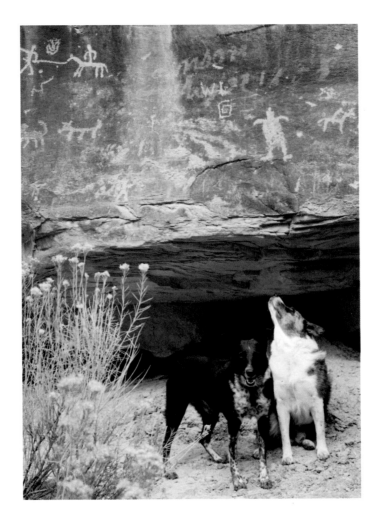

ABOVE: PETROGLYPHS, NINE MILE CANYON, NEAR PRICE, UTAH
RIGHT: SAGUARO CACTUS NEAR TUCSON, ARIZONA

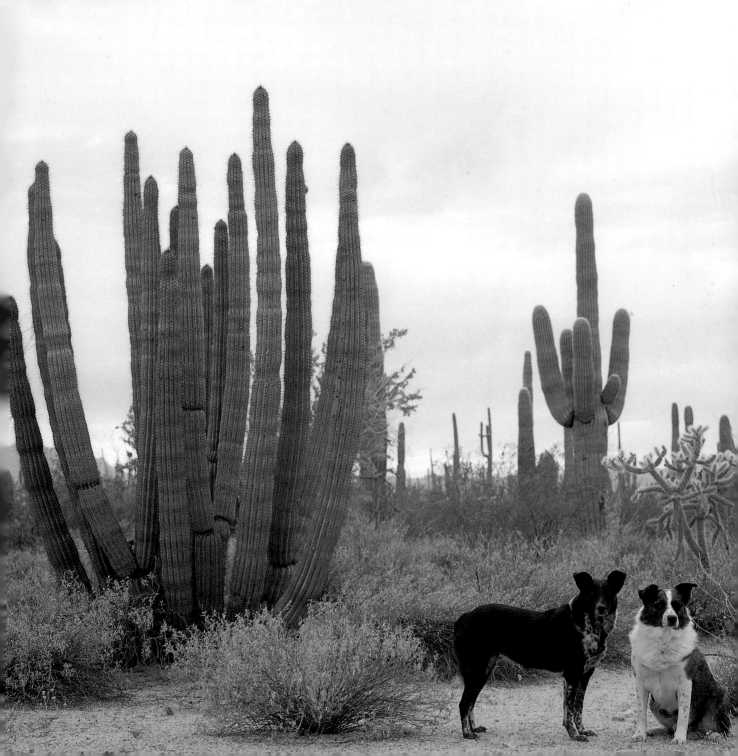

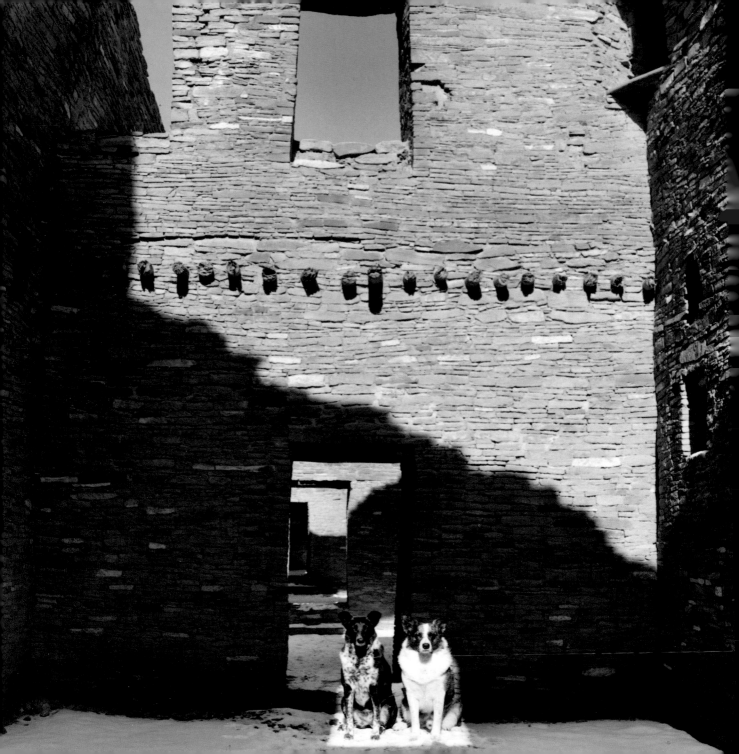

T he rules in national parks and monuments state that dogs must remain in vehicles, except in campgrounds and then on a six foot leash. Never on trails.

So how did I make these pictures in national monuments? I applied for and obtained special permission. Although all the park superintendents I approached were friendly, some turned me down because they were afraid that other people would arrive with their dogs thinking they could enjoy the same freedom.

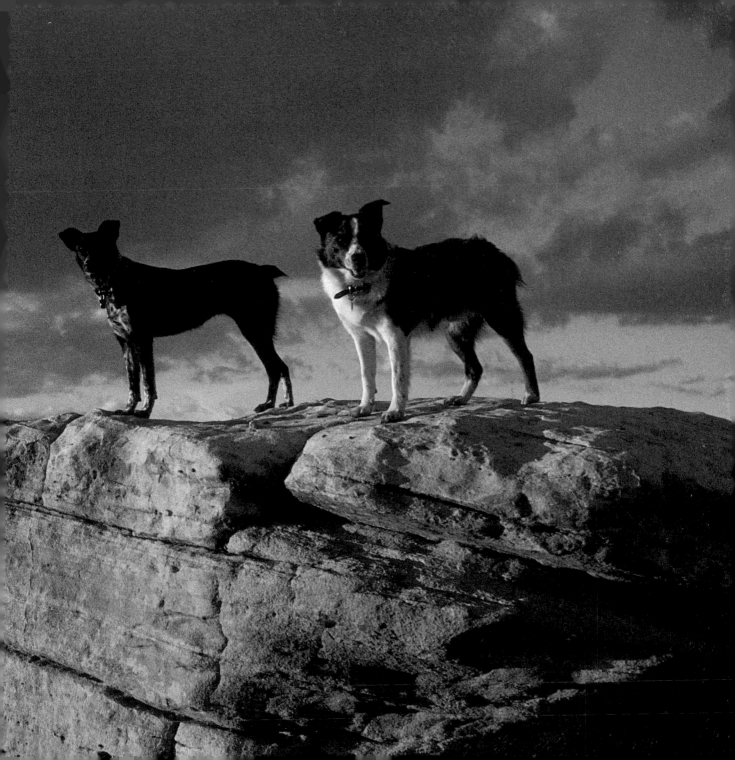

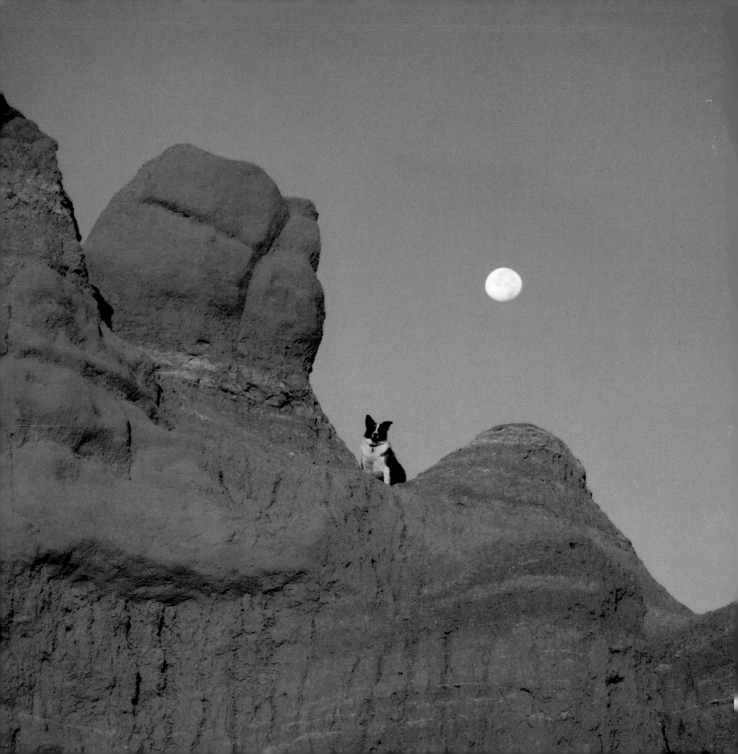

If you take your dog to a national park or monument, expect to be restricted to your vehicle and the campground. If you really want to see the parks, you would do better to leave your dog home. My choice is to drive through the parks with Bro and Tracy and then do our hiking and exploring in places with fewer restrictions such as Bureau of Land Management land, national and state forests, and state parks.

Camping is not for comfort. All too often it is too hot or cold, or windy and dusty or muddy. If you are camping with two dogs, that's eight more hot or cold, dusty or muddy feet. I go camping to be there.

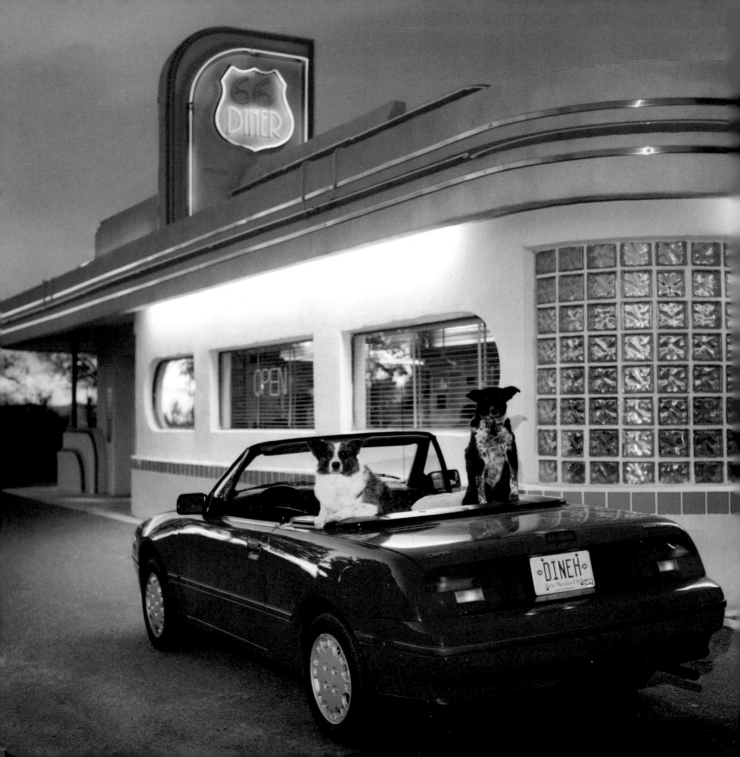

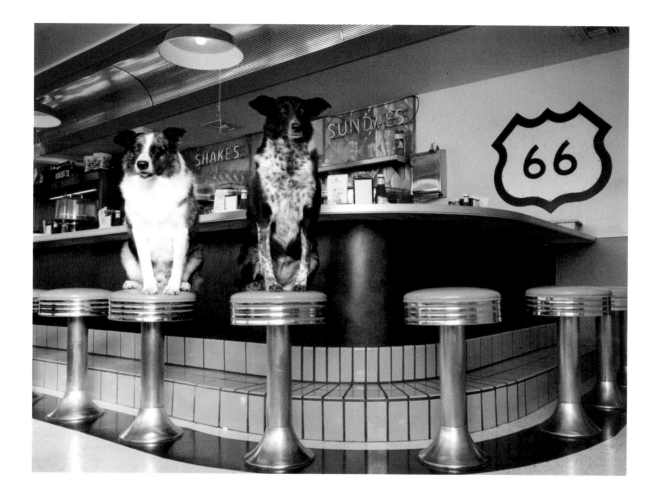

In Europe, dogs are allowed in many restaurants. I think that
is so civilized. Bro and Tracy are pictured here enjoying a special
visit to the Route 66 Diner. They wish they could come here
all the time.

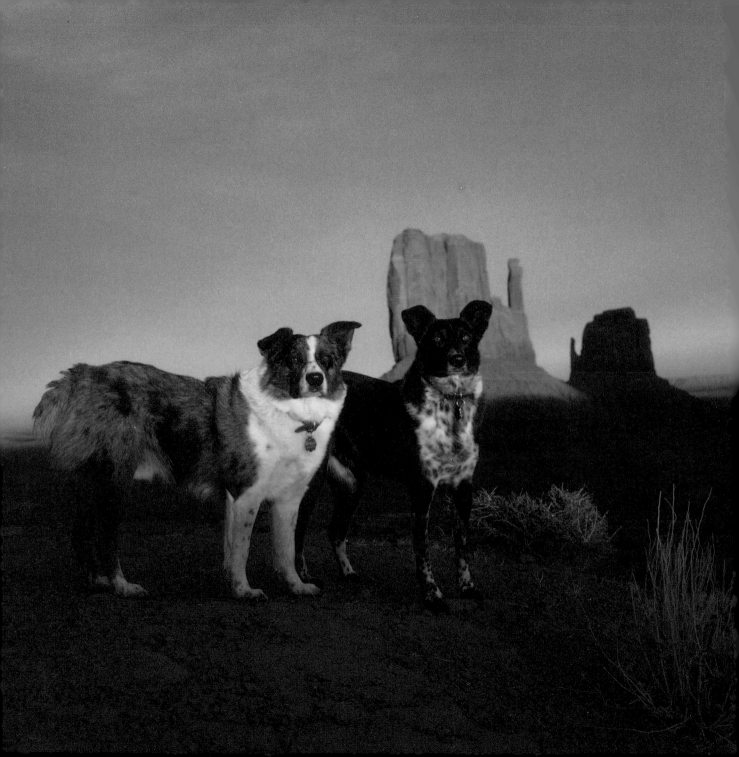

One December, we arrived in Monument Valley late in the afternoon. It was cloudy and cold. I got busy setting up camp before dark. For ten minutes before the sun set, the monuments lit up red against the dark clouds. The rest of the weekend was windy and bitter cold, but for ten minutes Monument Valley had once more revealed its magic and we were there.

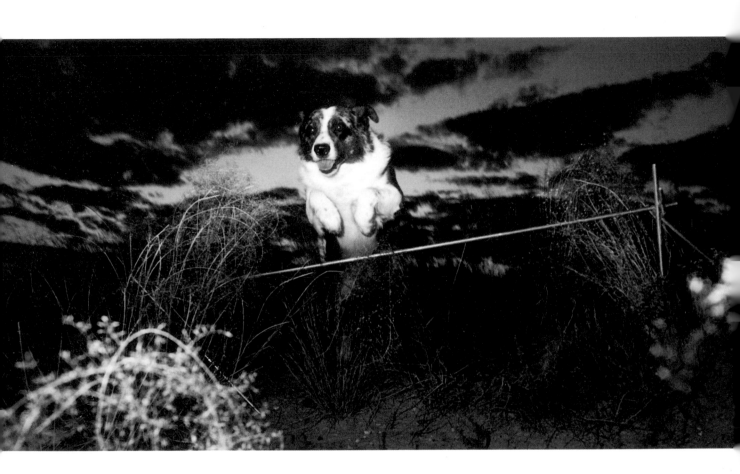

42

BRO JUMPING, CORRALES, NEW MEXICO

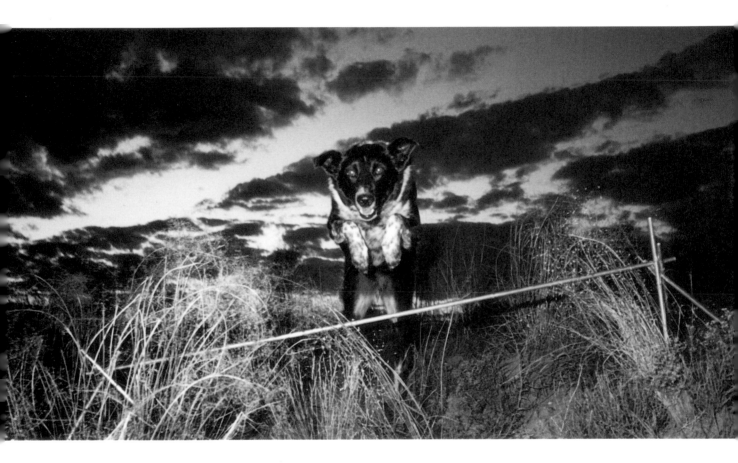

TRACY JUMPING, CORRALES, NEW MEXICO

E d and I love dogs, horses, the West.
Bro is on Ed's horse, Dineh.
Dineh is the Navajo word for the
Navajo people, who are Ed's people.

BRO'S MOONLIGHT RIDE, CORRALES, NEW MEXICO

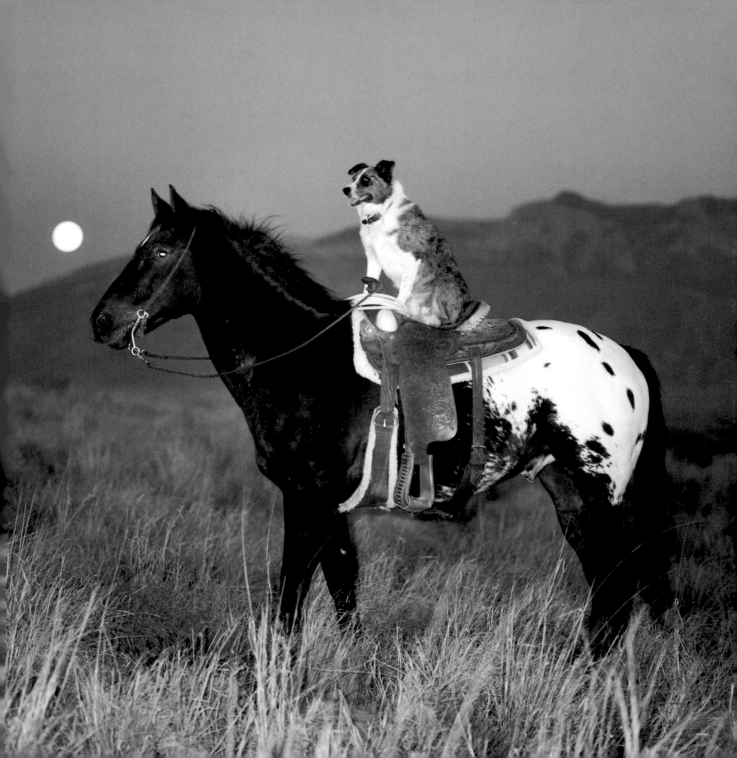

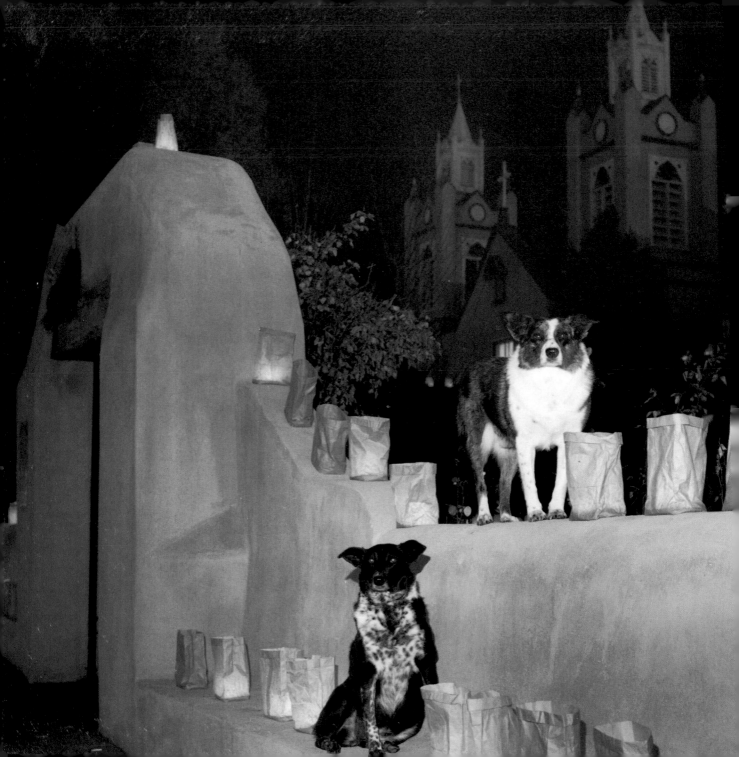

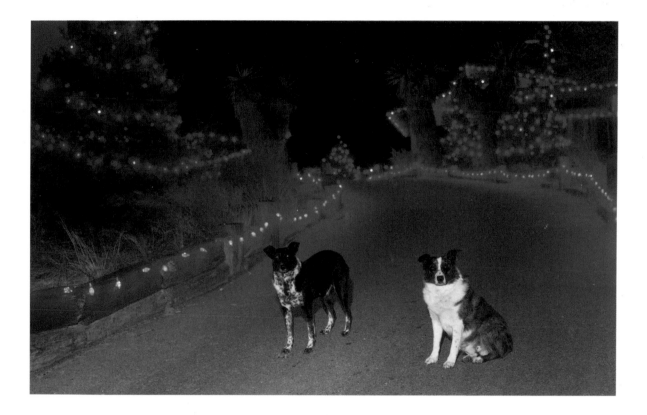

LEFT: CHRISTMAS EVE WITH FAROLITAS IN OLD TOWN, ALBUQUERQUE, NEW MEXICO
ABOVE: CHRISTMAS AT CORRALES, NEW MEXICO

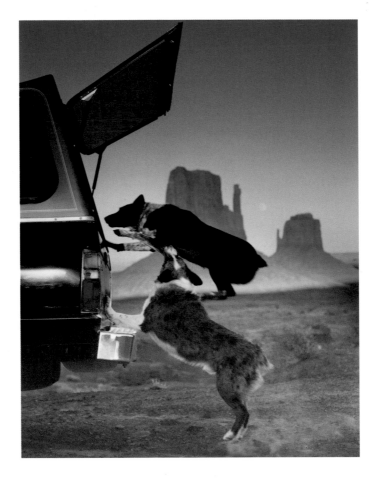

Training means teaching an animal to do our will. Communication means also wanting to know what they have to say. You need both.

The goal in raising an animal is to fit him into your life. You will be responsible for him as long as he or you live.

"Let's Go," Monument Valley, Utah